The Story of my Life

If

A STORY IS
IN YOU

It has to come out.

© 2016 Piccadilly (USA) Inc.

This edition published by Piccadilly (USA) Inc.

Piccadilly (USA) Inc.
12702 Via Cortina, Suite 203
Del Mar, CA 92014
USA

10 9 8 7 6 5 4 3 2 1

Printed in China

ISBN-13: 978-1-60863-159-9

The Story of my Life

Every life is packed with stories worth telling, and no one can tell them better than the person who lived them. But when you sit down to put it all into writing, where do you begin? The blank page is the most intimidating and procrastination-inspiring part of any writing project. Luckily, this notebook clears that hurdle for you. In its pages, you'll find prompts and exercises, written by a published writer, to help you bring your stories to life.

A good memoir is more than an autobiography that chronicles your existence; it's a life on a page full of description and dialog, a window into your past. If you're not a writer, even if you've never written before, don't worry: these prompts and exercises are designed to coax out your inner storyteller with specific, guiding questions.

This book will create a record of your life, but it will also help you express who you are as a person, and how you became who you are today. Whether you're writing down your life story for yourself, your close family, or for a wider audience, this book will guide you through the project and make your life story a joy to write and a pleasure to read.

Once you've done all of the prompts, you'll have a wealth of memories, anecdotes, and personal knowledge to work with. The question is, *what will you do with it?*

Childhood & Family

Every
CHILD IS AN ARTIST.
THE PROBLEM IS HOW
TO REMAIN AN ARTIST
once he grows up.

–Pablo Picasso

Make a basic timeline of your life. List the years of your life in increments of five, and write one short sentence that describes a major event that happened in each year. Fill in any major events in the gaps, like moves, births and deaths. If any question in this book doesn't apply to you, refer back to this list and write about something else.

1-5 years old _____

6-10 years old _____

11-15 years old _____

16-20 years old _____

21-25 years old _____

26-30 years old

31-35 years old

36-40 years old

41-45 years old

46-50 years old

51-55 years old

56-60 years old

61-65 years old

66-70 years old

71-75 years old

76-80 years old

81-85 years old

"My family ancestry originates from..." Go into as much detail as you can.

What is the history behind your family's name?

How and where did your grandparents meet?

(If you don't know, this is a great opportunity to find out.)

What events happened in history the year you were born?
Research the details, and write them down.

Fill in the blanks: "My mother was born in _____ in the year _____ . Her parents' names were _____ & _____ . She grew up in _____ and was one of _____ children.

Write about your earliest childhood memory of your mother.

Fill in the blanks: "My father was born in _____ in the year _____ . His parents' names were _____ & _____ . He grew up in _____ and was one of _____ children.

Write about your earliest childhood memory of your father.

What noises did you hear when you woke up in the morning?
Go into as much detail as you can.

Top 10 time! Imagine your childhood bedroom.

List ten objects you remember from the room, and describe what they meant to you.

1. _____

6. _____

2. _____

7. _____

3. _____

8. _____

4. _____

9. _____

5. _____

10. _____

What pets did you have in your household growing up?

How big a part of your life were they?

Describe, using all five senses, your childhood home. If you moved around a lot, describe the one you remember best.

What role did you play in your family's dynamic? (Peacekeeper, comedian, youngest/oldest, troublemaker, etc.) Tell a story that demonstrates you playing that role.

What was distinctive about your hometown?

What figures from that community stand out in your mind?

"When school let out for the summer, I spent those warm weeks..."

Go into as much detail as you can.

Describe an illness or injury that stands out in your memory. What happened, how long did it take to recover, and what do you remember from the recovery?

Tell about the first time you kept a secret. Was the secret your own, or someone else's? Did it ever come out? It's time to tell all.

Top 10 time! List the top ten smells you associate with your childhood.
What does each one signify?

1. _____

2. _____

3. _____

4. _____

5. _____

6. _____

7. _____

8. _____

9. _____

10. _____

What special traditions did you have in your household growing up?

What religion are you, and what role did that play in your youth?

Using as many smells, colors, and textures as you can remember, describe your childhood kitchen.

"When I was a kid, my favorite TV show was _____ because..."

Top 10 time! List the things you did as a child to express your creativity.

What drew you to each one?

1._____

2._____

3._____

4._____

5._____

6._____

7._____

8._____

9._____

10._____

Name an object from your childhood that you still own.

What is the story behind it, and why have you kept it?

Who was your best friend, and what did you do together?
Did you stay friends into adulthood? If not, why?

Top 10 time! List your favorite foods and drinks that your parents made.

Go into as much detail about each one as you can.

1. _____

2. _____

3. _____

4. _____

5. _____

6. _____

7. _____

8. _____

9. _____

10. _____

"My favorite childhood vacation was..." Go into as much detail as you can.

Which of your parents do you take after, and in what way(s)?

"Where were you when..." No matter when you were born, something huge has happened in the world within your lifetime. Tell what it was, where you were when it happened, and how it affected you.

"The scariest thing that ever happened to me was..." Go into as much detail as you can.

Describe your parents' parenting style.

Tell a story that shows how much (or how little) freedom you had.

"The most memorable family holiday was..."

Word association exercise: *don't think, just write!*

What person comes to mind when you hear the word "hero"? Why?

What event(s) brought you closer as a family?

How well did you know your extended family—cousins, aunts and uncles, etc.—list their names, how you're related, and their roles in your childhood.

Describe your first big disappointment.

Open a dictionary to a random page and, without looking, point to a word. What memory or relationship comes to mind when you see that word, and why?

When you were young, what was your favorite thing to do, and why? How did it make you feel? This can be a hobby, a sport, an art, anything you were passionate about.

Word association exercise: *don't think, just write!*

What memory comes to mind when you hear the word "accident"?

Name a song that brings back a strong memory for you, and write about that memory.

"If I could relive one memory, just for fun, it would be..."

Mention a detail for each of the five senses.

"The best gift I ever received was..."

Word association exercise: *don't think, just write!*

What person comes to mind when you hear the word "money"?

Top 10 time! Name your top ten role models growing up. These can be people in your life, fictional characters, or cultural figures. What qualities did you admire in them?

1. _____

2. _____

3. _____

4. _____

5. _____

6. _____

7. _____

8. _____

9. _____

10. _____

Write about a time when something that was supposed to be joyful turned out badly.

What role did books play in your childhood?

How high-tech was your childhood?

What technologies existed in your youth, and what role did they play in your life?

Write about a time when you were given responsibility as a child.

Go into as much detail as you can.

Discuss how you learned about giving to others.

Remember a time when you were looking forward to something for a long time. What was it, and did it live up to your expectations?

What sport(s) interested you, and how did you participate?
If not, talk about another pastime.

Describe a time when you got very angry with one or both of your parents.

What was your favorite thing to do in the winter? Tell a specific story about it.

"My most memorable birthday was…"

How did you like to dress as a child?

Did you choose your own clothes, or did your parents choose them for you?

Did you have a childhood nemesis? Write about that dynamic.

If you didn't, write about someone who made you uncomfortable.

Write about where you went in and around your home or neighborhood to be alone. Why did you choose that spot, and what did you do there?

"The first time I intentionally lied..."

Write a letter to your childhood self giving advice, guidance, and perspective.

Young Adulthood & Firsts

A person

WHO NEVER

MADE A MISTAKE

never tried anything new.

–Albert Einstein

"The first time I drove a car..."

What did you want to change about your home life, and why?

What is your saddest memory from your youth?

"The first time I disagreed with my parents..."

Describe a friendship from childhood in which you grew apart. What changed, and why?

Describe your physical appearance as a teenager.

How aware were you of how you looked, and how did you feel about your body?

Write down everything you remember about your first day of high school.

Word association exercise: *don't think, just write!*

What memory comes to mind when you hear the word "spontaneous"?

What kind of learner were you in high school, and how did you do academically?

"My first crush was..."

"My first heartbreak..." (This does not necessarily have to be romantic.)

What were you really good at outside of school as a young adult?

Did you pursue it, and how?

Write about your first experience losing someone you loved.

Write about a time when something turned out differently than you expected it to.

"When I was young, my biggest fear was..."

Word association exercise: *don't think, just write!*

What memory comes to mind when you hear the word "dare"?

What did you do that your parents didn't want you to? Did you get caught?

What story comes to mind when you hear the phrase, "rite of passage"?

Top 10 time! List the top ten songs you loved as a teenager.

What memories stand out with those songs in the background?

1._____ 6._____

_____ _____

_____ _____

_____ _____

2._____ 7._____

_____ _____

_____ _____

_____ _____

3._____ 8._____

_____ _____

_____ _____

_____ _____

4._____ 9._____

_____ _____

_____ _____

_____ _____

5._____ 10._____

_____ _____

_____ _____

_____ _____

Describe your personality when you were a teenager. Were you a nerd, an introvert/ extrovert, a leader, an athlete, or did you keep to yourself? Tell a story that shows this side of you.

When you were in high school, what did you want to be "when you grew up"?

How did your relationship with your parents change in high school?
Tell a story that shows this new dynamic.

"My first kiss was with..."

"My favorite high school teacher was..." Tell a story that you remember fondly.

When did you start becoming romantically aware? How did this affect you?

You saw this coming. It's time to tell all about your first love!

What role did you play in your social circle?

Tell a story that shows how you fit into the group.

What was your favorite book as a teenager, and why?

What is your favorite memory as a teenager with your friends? Recreate the scene so a reader feels like they're there.

"The adult who influenced me the most was..."

Describe your first job.

What did you do with your first paycheck? Why was this important to you?

What college did you go to, and why did you choose it? If you didn't go to college, talk about why you didn't and what your goals were as you moved toward adulthood.

How did you react to being away from home in college? If you lived at home or didn't go to college, how did your role change in your home in this part of your life?

Word association exercise: *don't think, just write!*

What memory of this time period comes to mind when you hear the word "failure"?

Name the most important person you met in college or in your post-high school life. Recall a memory that you cherish from that time with that person.

What was your major in college, and how did that change as you progressed toward graduation? If you didn't go to college, what was your career goal, and why?

Top 10 time! What stressed you out the most? List ten things you did in your late teens and early twenties to relax and release it.

1. _____

2. _____

3. _____

4. _____

5. _____

6. _____

7. _____

8. _____

9. _____

10. _____

Describe your romantic life in college or at this age.

Who did you like, date, form lasting relationships with?

Word association exercise: *don't think, just write!*

What memory comes to mind when you hear the word "rejection"?

Don't blush.... Go into whatever detail you're comfortable with about your first "time".

What obstacles did you encounter in college/right after high school, and how did you overcome them?

"The first time I could legally vote, I voted for..." If you didn't vote, write about how aware you were of politics and what your opinions were.

Top 10 time: List your top ten friends when you were in college (or right after high school). Where are they now?

1. _____

2. _____

3. _____

4. _____

5. _____

6. _____

7. _____

8. _____

9. _____

10. _____

What non-academic lesson did you learn in your late teens and early twenties that has stuck with you?

Describe the first car you owned.

How did it come into your life, and how did it change your life?

"The first time I had to speak or perform in front of a crowd..."

Word association exercise: *don't think, just write!*

What memory comes to mind when you hear the word "pride"?

What were you doing when you first felt like an adult?
Set the scene, and don't leave out any details.

In dialog form, write out an important conversation you had with one or both of your parents that showed your relationship dynamic at this age.

What happened the first time you got stitches?

Describe the first time you ever stood up for yourself.

Describe your dream at this age, your vision for your future.

What is the best advice you received in this time of your life? Describe the circumstances that brought you to this advice, who gave it, and what you did with it.

"The first time I did something illegal..."

Top 10 time! List the top ten things that motivated you and got you excited. What did you get hyped up for?

1._____

2._____

3._____

4._____

5._____

6._____

7._____

8._____

9._____

10._____

Were you a competitor, a collaborator, or a loner? Tell a story that shows this.

Write about your relationship with the natural world, outside of urban or neighborhood life.

Describe the first time you went on a trip without your parents.
Include details that touch on each of the five senses.

Write a letter to your teenage self about how much your life will change as an adult.

Adulthood

Anybody

WHO KEEPS
THE ABILITY
TO SEE BEAUTY

never grows old.

-Franz Kafka

At what age did you move out of your parents' house, and where did you go? Describe your first apartment.

Describe a time when you moved up the ladder at work or took on more responsibility.

Did you continue your education beyond college? What degree did you pursue, and why? If you didn't, discuss how you improved yourself independently.

What were your career goals, and what action did you take to achieve them?

Tell that funny anecdote you always bring up at parties.

"The first time I went on a real date..." (Include a detail that touches on each of the five senses.)

Discuss how you balanced your work and personal life when you were in your twenties. What did you enjoy doing outside of work?

Who was/is your best friend as an adult?

How did this person come into your life, and how is this friendship different from others?

Open a dictionary to a random page (again) and, without looking, point to a word. What person from your adult life comes to mind when you see that word, and why?

Describe your social circle as an adult.

Who was/is in your "tribe" and what did/do you do together?

Top 10 time! Name ten people you call first when something major (good or bad) happens in your life, and tell why they are your go-to guys.

1. _____

2. _____

3. _____

4. _____

5. _____

6. _____

7. _____

8. _____

9. _____

10. _____

As you became aware of the wider world and current events, what issues were important to you?

In dialog form, record the first time you had an adult conversation with one or both of your parents.

When (if ever) did you go from a renter to an owner? Describe the first property you owned and why you chose it. If you didn't, describe your favorite home using all five senses.

When and how did you meet "the one"?

Alternative: Discuss the romantic relationship that is most significant to you.

What did you like to talk about?

Describe the early part of your married/life partner relationship.

What did you like to talk about?

 Alternative: Did you ever live with another adult, or are you a lone wolf, and why?

 What were your favorite and least favorite things about this living situation?

What common interests did/do you share with your first (or only) spouse?

Alternative: What qualities did you find attractive in others, and why?

When did you know your spouse/partner was someone with whom you wanted to spend the rest of your life? Describe what you were doing the moment you knew.

Alternative: Discuss the biggest change you made by choice in your adult life. How did you know a change was needed, and what did you do to change it?

Describe a challenge you faced as a couple and how you overcame it, if at all.

Alternative: Write about something completely impractical that you bought as an extravagant gift for yourself.

What new personal traditions did you start as a couple?

Alternative: What traditions from childhood have you carried into your adult life?

Did the marriage last? If it ended, discuss why. If you are still together, how has your relationship grown?

Alternative: Describe a time when you felt a certain way about someone and the feeling wasn't mutual.

Did you have more than one "one"? If you had more than one life partner, how did you meet, and how did the history of the first affect the early days of the second? If you didn't have more than one, how did you celebrate your tenth anniversary with your one-and-only?

Alternative: In your opinion, what human values have changed the most since you were a child? Make sure you use examples!

Describe your favorite local hangout. Where was your go-to place outside of home and work, and why? Recreate the atmosphere using all five senses.

How did your first child change your life? What adjustments did you and your spouse/ co-parent (or just you if you were a single parent) make to your work and social life?

Alternative: Are your parents still in your life? If so, describe your relationship using a recent encounter. If not, when and how did they leave it, and how did your life change?

Name each of your children and describe their personalities when they were young.

Alternative: Discuss your views/plans about having children. Did/do you want them but it hasn't worked out, or was not having children a conscious choice?

What did you do together as a family when they were young?

Alternative: What is your favorite time of the year, and why? Recall a fond memory of this time using all five senses.

Top 10 time! List ten parts of yourself, physical or mental, that you recognized in your child(ren). Is each one a good or bad thing, in your opinion, and why?

Alternative: List ten parts of yourself, physical or mental, that you admire. Don't be humble!

1._____

2._____

3._____

4._____

5._____

6._____

7._____

8._____

9._____

10._____

Talk about something you always wanted to learn how to do but didn't.
Explain why you were drawn to it and what kept you from pursuing it.

Describe a time when you played a mentor role in someone else's life.

Tell a story about being pleasantly surprised.
You thought something was going to be awful, but it turned out to be a positive thing.

What children, not your own, have played a big part in your life?

Describe a time when your attempt to help someone only made it worse.

Top 10 time!

List ten vacations or adventures you went on as a family. Where did you go, who chose the destination, and what memories stand out?

Alternative: List ten trips or adventures you took as an adult, either alone or with others. What was your favorite part of each trip?

1._____

2._____

3._____

4._____

5._____

6._____

7._____

8._____

9._____

10._____

What was your parenting style (be honest)? Were you flexible and permissive, authoritative, or somewhere in between? Looking back, do you wish you'd been different, or do you stand by your methods?

Alternative: What kind of friend are you? Are you too giving, too selfish, or somewhere in between? Are you the one people come to for advice, or for a stiff drink and a joke? Tell a story about a friend's struggle and what you did/didn't do to help.

Write about a big change or event that your family went through together.

This can be a death, a divorce, a financial struggle, a move, etc.

Alternative: What loss has affected you the most in your adult life?

This can be a person, a job, an object, etc.

When you had/have strong opinions, do you voice them or keep them to yourself?
Tell about a specific time when you did this.

How did/does money affect your life? Did you struggle, did you have what you needed, or did you have an abundance? In any case, tell a story that shows how your finances influenced your decisions. How did this change over time (get better/worse)?

If you could have lived anywhere in the world at this time in your life, where would it have been, and why?

How have your religious beliefs developed up to this point?

Write about your relationship with food. What were/are your favorite meals, and did/do you cook? If you don't, who does?

Word association exercise: *don't think, just write!*

What memory comes to mind when you hear the word "betrayal"?

Think of a time when you overheard something you weren't supposed to.
What effect did it have on you?

Top 10 time: List your favorite cities—all over the world—to which you've traveled. Include the dates, circumstances, and with whom you traveled.

1. _____

2. _____

3. _____

4. _____

5. _____

6. _____

7. _____

8. _____

9. _____

10. _____

Word association exercise: *don't think, just write!*

What ideas come to mind when you hear the word "politics"?

What do you do to "pay it forward"?

Where did/do you go to temporarily escape your daily life, and why are you drawn there? Describe the place using all five senses.

Word association exercise: *don't think, just write!*

What memory comes to mind when you hear the word "misunderstanding"?

What assumptions do people make about you when they first meet you, and why? Are they right or wrong?

What role did addiction play in your adult life? This can be a negative or positive addiction—a substance, an activity, anything to which you were "addicted".

Top 10 time! List ten things that happened in politics or popular culture that stood out to you, and why.

1. _____

2. _____

3. _____

4. _____

5. _____

6. _____

7. _____

8. _____

9. _____

10. _____

Describe a time in your adult life when you felt lost and how you dealt with it.

What was/is your personal style? How do your clothing choices reflect your personality?

"The strangest thing that ever happened to me was..."

What do you regret the most from your adult life, and what would you do to change it if you could?

Write a letter to your adult self giving yourself solace about something that made you sad.

Retro. spective

The

UNEXAMINED LIFE

is not worth living.

–Socrates

How do you pay tribute to people you've lost?

What movie have you always watched again and again, and why?

What personal ritual has stuck with you your whole life? Why is it significant?

If money were no object, describe something you would have done or tried in your life that you didn't. Describe why you chose that "something".

Top 10 time! List the top ten people you'd like to thank.

1.

2.

3.

4.

5.

6.

7.

8.

9.

10.

Describe the most difficult thing you've ever had to do, either physically or mentally. Did you do it alone, or did you have support?

What quality is your Achilles heel? You've tried to change it, but it's just who you are. How did it hinder your life and/or relationships?

If you could do one thing without any legal or physical consequences, what would it be, and why?

Choose one person from your entire life, and write that person a letter to clear up something he or she never really "got" about you.

If you had to choose one "true love" from your life, what or who would it be?
This can be a person, a vocation, a place, whatever comes to mind first.

Describe a moment of selflessness. Go into as much detail as you can.

Name one person from your whole life who made you laugh the most. Describe what that person did that was funny, and tell a story that always makes you smile.

What has been your greatest fear? Write about your attempts to either avoid or overcome it, then list what you would you have done if you hadn't been afraid.

Reflect on a person in your life who wasn't a blood or legal relative whom you still consider "family".

Top 10 time! List the top ten people to whom you'd like to apologize, and why.

1. _____

2. _____

3. _____

4. _____

5. _____

6. _____

7. _____

8. _____

9. _____

10. _____

Do you believe that everything happens for a reason?

What in your life makes you think so/not?

In what moment of your life did you feel the most loved?
Go into as much detail as you can.

"If I could go back and make one decision differently, it would be..."

Describe something you've done about which you have no regrets.

With perspective on your side, you would have done it exactly the same.

If you could change one major historical event outside of your own life, what would it be, and why? Be as detailed as you can.

Refer back to the timeline you did in question one.

Did you miss anything in the previous pages?

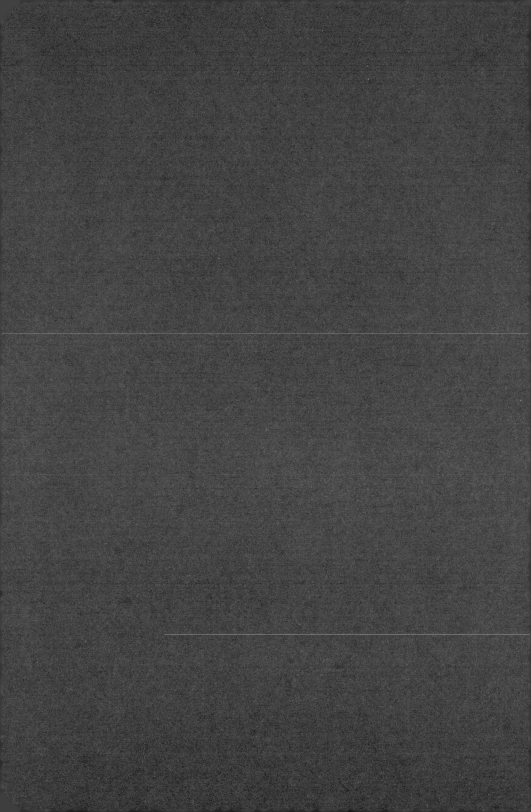